The Worst Salesman in the WorldSM

Becoming the **Best** by Learning from the Worst

Joel Saltzman

Also by Joel Saltzman

Selling With Honor
(with Lawrence Kohn)

If You Can Talk, You Can Write

If You're Writing, Let's Talk

Under the pen name, J.S. Salt

Always Kiss Me Good Night

The Worst Salesman in the World℠

Becoming the Best by Learning from the Worst

Joel Saltzman

A *Shake It!* Original

The Worst Salesman in the World℠
by Joel Saltzman

The Worst Salesman in the World is a Service Mark for Joel Saltzman's speeches, workshops and services in the field of selling. Registration pending.

Copyright © 1999 by Joel Saltzman

A *Shake It!* Original, First Edition

January 1999

00 99 0 9 8 7 6 5 4 3 2 1

Published by
Shake It!
Los Angeles, CA
Toll free: (877) *Shake It*
INTERNET: www.**shake**that**brain**.com

This book is available at special quantity discounts for bulk purchase for sales promotions, premiums, fund-raising and educational use.

Special books, or book excerpts, can also be created to fit specific needs.

ISBN: 0-9667156-0-8
Printed in the United States of America

Contents

for
Willy

**"I thought it was illustrative,
funky, unconventional.
And it really reflected
the risk I wanted to take."**

— John Kilcullen, on creating the best-selling
" ... *for Dummies*" series of books

Conclusion

This book will challenge some deep-seated conclusions you have about selling.

As you read each chapter, ask yourself if you're guilty of similar misguided thinking. If you are, learn to take this bone-headed advice and turn it on its head.

This is the essence of *The Worst Salesman in the World*, a compendium of bad sales behavior that all too many of us have practiced or experienced first hand. In fact, much of the "advice" you'll be reading stems from my having been treated so poorly or ineptly by a salesperson, I just had to write about it.

Study well what this book has to offer — and learn to do the opposite. It will reward you, your company, and the people to whom you sell.

— Los Angeles, CA
August, 1998

Then Again ...

Following many chapters you'll find a box that looks like this, helping you to *Shake That Brain!*SM and discover a more enlightened point-of-view. So keep your eye out for these "Then Again" boxes. The wisdom they contain will lead you to happier buyers and increased sales.

Keep Your Efforts Seller-Centered

Be Helpful to You

As a salesperson, you have the opportunity to help people get what they need at a fair, honest price.

But why?

You don't know them, owe them, or have a reason to care.

Be helpful to *you* by paying maximum attention to wants and needs.

Buyers, for example, want to be treated fairly, want a good deal and want their salesperson to tell the truth. None of these wants, however, compares with *your overwhelming need* to sell as much as possible for as much as possible.

Avoid Asking Questions

By asking questions and searching for people's needs, you risk being overwhelmed by a variety of needs.

Better to *avoid* asking questions and treat everyone the same.

Leave the probing to surgeons and shrinks. As a salesperson, there are only two questions to ask: "How much can I sell you?" and "Why not let me sell you more?"

Talk More Than You Listen

A salesman who dominates the conversation by doing all the talking is likely to overlook his prospect's needs — which is good. Because needs can vary, and selling shouldn't.

If your prospect manages to get a word in edge-wise, avoid the trap of paying attention to his words. Instead, use this momentary interruption to remind yourself: *What was I planning on saying next?*

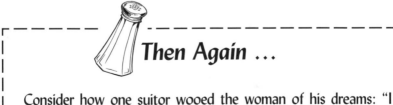

Then Again ...

Consider how one suitor wooed the woman of his dreams: "I listened to what she wanted to hear and I made sure I said it."

Sell Features, Not Benefits

It's easy to sell benefits, such as: "When you purchase this product, it will benefit me because I get a commission."

Better to sell features, such as: "This product boasts many fine and useful features, many of which you may never need or use."

That's a statement no one can refute.

Besides, you never know when your customer's needs may change. What if he's stranded somewhere and suddenly needs that Swiss Army knife with a flare-launcher and two-way radio inside? Wouldn't you feel guilty for not having sold him one? *You bet you would!*

Meanwhile, selling features lets you create an informative I-know-what-I'm-talking-about presentation. And a feature-by-feature approach has the *added* feature of protecting you from rejection — because a prospect can't reject *you* when all you're presenting is information.

 Then Again ...

Selling benefits lets your customer know: *Here's how this product or service will benefit YOU, how it will IMPROVE YOUR life.*

Counter Objections With Pat Responses

There are a finite number of buyer objections. Learn to counter and overcome them with well-rehearsed, pat responses.

If they say: "It costs too much."

You reply: "You're judging the cost relative to your income. If you made more money it wouldn't be a problem, would it? Besides, everyone knows that when you spend more you *make* more. So what you perceive as a 'cost' is really an opportunity for creating wealth."

If they say: "Let me think about it."

You reply: "Let me think about it *for* you. It's part of the service I provide." *Then pause for a second and say:* "Well, I've thought about it. This is a deal you just can't pass up."

If they say: "I'm happy with what I'm using."

You reply: "And I'm happy with my spouse. But that doesn't mean I'm not interested in trading up."

If they say: "How do I know this will do everything you say it will?"

You reply: "How do you know you'll be alive tomorrow? And if you're not, won't you regret not buying today?"

If they say: "I don't need this product."

You say: "And I don't need a hassle. Certainly not from you. But I am willing to put up with you until you buy the goods."

Finally, if they say: "Look, under no circumstances am I going to buy this product from you."

You say: "What color would you like?"

True Story

After moving to California, I got a call one night from a telemarketer who wanted to interest me in a "permanent retirement property." (His euphemism for a grave site.)

"Actually," I told him, "I already own some 'property' in New York."

To which he replied—without so much as missing a beat—"Have you thought how you'll get there?"

"I was thinking of driving."

Know When to Discount

As soon as the buyer offers resistance, *discount.*

Not only can discounting turn a No into a Yes, discounting your price is the easiest way to make less money. And be sure to act fast: *The sooner you start to offer that discount, the sooner you can start to make less money.*

Then Again ...

Better to *prevent* price objections by building in so much perceived value that your deal becomes an irresistible bargain.

In fact, there's only one instance where discounting makes sense: When you need to match someone else's price — but only if they're selling the *exact* same goods and your customer has one foot out your door.

Sell Each Customer Exactly What *You* Want

Rather than buying off-the-shelf, many customers will want you to customize — to create a product that's just right for them. *Don't.*

Customizing is a slippery slope and there's no way back. It takes extra time, extra effort, and creates a host of extra problems:

1. *It kills your sales pitch.* Custom-selling means custom-pitching. So no two pitches can ever be the same.

2. *It shows people you care about them.* Nothing could be worse. Now each of your customers will see themselves as people with *individual* needs and concerns that you're in the habit and market of addressing.

3. *It raises the bar to unrealistic heights.* Learning about your customers and meeting their needs with "special care" is all fine and good — at first. But little by little, the customer will grow to expect more and more: More individual attention, more customizing of services and more help and service than you can possibly provide. All of which translates into an undue burden, a Frankenstein customer that *you've* created.

Avoid customization. Sell each customer exactly what you want and leave the making of monsters to your naïve competition.

Reward Indecision With Increased Options

When customers can't decide between various models, reward their indecision with *increased* options.

Say they can't decide between three different cameras. Offer them a fourth, even fifth possibility. If they still can't decide, pull out more options. The more choices you give them, the more confused they'll become. Adding product literature is another option. "Take these brochures home. Study every product and all their features. Maybe that will help you decide."

Soon, they'll be so overwhelmed with cameras and catalogs that they may leave without making a purchase — which isn't good. If you're lucky, though, they'll throw up their hands and beg you: "Please, make my decision *for* me. Just tell me what to buy and I'll do as I'm told."

This is just where you want them — so overwhelmed with alternatives you get to "make their day" with the product and price that works best for you.

Then Again ...

There's nothing smarter than asking questions and *decreasing* choices based on your customer's needs. It's a service to your buyer — and to you.

Respond Appropriately to Buying Signals

Through a variety of verbal and non-verbal signals, buyers may indicate enthusiasm or excitement about your product. This is what's called a "buying signal," signaling to the seller they're ready to buy. It's your job to know how to read these signals and respond appropriately as you *challenge* each signal.

VERBAL BUYING SIGNALS

If they say: "Could I see that again?"
You reply: "Haven't you seen it enough already?"
If they say: "How soon can I get one?"
You reply: "Sorry, we can't guarantee a delivery date."
If they say: "How much would it cost for a hundred of these?"
You reply: "Same price times a hundred."

NONVERBAL BUYING SIGNALS

If they: Lean forward in their chair.
You: Sit back in yours, confident they'll come to you.
If they: Start writing or making calculations.
You: Ask them to stop, insisting they give you their undivided attention.
If they: Touch their face, feel for their wallet or start looking for their check book.
You: Ask them to stop, insisting they give you their undivided attention.

Then Again ...

The moment you hear or see one of these buying signals, you know it's time to go for the close. Or at least a "trial close." Why not try the...

Ask-For Close
"You really like this. Why don't we wrap it up?"

Take-Away Close
"If you don't buy it, you don't get to have it."

Either-Or Close
"Would you like the blue one or the red one?"

Add-On Close
"Like some extra batteries to go with that?"

Order Form Close (Wildly Manipulative)
You start filling out the paperwork, or ask *them* to start.

Puppy Dog Close
"Why don't you take it home, see if you like it? You can always return it."

This is akin to the car-selling ...

Cream Puff Close
"Take it home. Drive it. You'll love it!"

Keep Selling After You've Made The Sale

Once you know they're ready to buy, *keep selling*. Impress them with benefits, features and — in the event you know something about what you're selling — every bit of minutiae you can muster. This is your chance to shine, to tell them about micro-encoding, digital feedback loops and that 100% genuine fake wood veneer. To not just sell them, to *overwhelm* them.

And don't quit talking till they beg you to stop.

Couldn't that sour their decision to buy, you ask? Make them wonder: *If this is such a good deal, why does he keep trying to talk me into it?*

Then they weren't really sure, were they? Better to keep on selling even if it sends them fleeing for the door. At least they'll leave as knowledgeable consumers.

Wait Until They Ask, "Can I Buy This?"

By now, your customer may have sent you a host of buying signals, like telling you how much he likes your product or how well it would suit his needs. Still, it's not up to you to ask for the sale.

Regardless of his buying signals, avoid being perceived as pushy or rude by waiting until he takes out his wallet, hands you his credit card and says the words: "Can I buy this?"

Then Again ...

Find a way to ask for the sale. "Which color would you like?" "How would you like to pay for that? Cash or charge?" *There is not a person on earth who has not been sold with one of those closers.*

I shop for my clothes at a place called David's. Soon as I try on a pair of pants, David says: "Let's mark 'em up. See how they'll look." Next thing I know, his tailor swoops in and I'm marked and pinned. "Now let me show you a *jacket* for that."

Without David — and this is no exaggeration — I would be *naked* wherever I went.

Learn to Outwit Them with the Ben Franklin Close

When all else fails, ask: "Do you know how Ben Franklin would make up his mind? He'd make a list of all the reasons why he SHOULD do something, then make a list of all the reasons why he SHOULDN'T. Whichever list was longer, that's the one that would direct his behavior."

For example: Let's say you're trying to convince a prospect to start smoking and the prospect balks. First, create for him a list of well-rehearsed reasons why he SHOULD start smoking:

1. You'll look cool.

2. You'll always having something to do.

3. It helps you relax.

4. Smoking a cigarette is "just the thing" for after a meal.

Next, invite him to create his own list. Not having thought about it in advance, whatever list he does create will no doubt be shorter than yours. For example, he might respond:

1. It will give me cancer.

2. If I get cancer, I could die.

"There we have it," you say. "You only have two reasons why you SHOULDN'T be smoking and I have *four reasons* why you SHOULD."

"You're right," says your prospect. "It's a much better idea to start smoking than not."

And just like that, you've *sold* him!

Then Again ...

While many famous sales gurus still advocate the Ben Franklin Close, this strategy is wildly manipulative. Moreover, this modern retelling of Franklin's technique — which fails to consider the relative importance of each SHOULD or SHOULDN'T — just doesn't hold water, unless you're dealing with a very stupid person.

Let Them Know They've Made a So-So Purchase

In the event you actually sell something, complete the sale by telling your customer: "I hope it works out." And be sure to remind him: "What I said was 'This product or service *could* change your life.' It could also work out to be a complete waste of money."

In the event his purchase falls short of the miracle solution you helped him envision, these subtle disclaimers will cancel his ability to complain.

Then Again ...

Instead of saying, "I hope it works out" — words many sales-people foolishly spout — learn to cap each sale by letting your buyer know he's just made an outstanding purchase. Your hidden message? *You were smart to buy this and you'd be a fool to return it.*

After graduating college and knowing nothing about the real world, I demonstrated my lack of knowledge by buying a car from a used car salesman. Handing me the keys, he said, "Heck, if you want to sell this baby a couple of years from now, just take off a hundred dollars and you'll sell it in a second." Imagine how good that made me feel, knowing I had made such a smart purchase.

Instead, I wound up sinking a fortune into that car just to keep it running. Still, every time I brought it for repairs, I kept hearing that salesman's words, reminding myself what a smart purchase I had made. All I had to do, I'd tell myself, was get this "one last repair" out of the way.

In the end, I sold that car to Bruno's Junk Yard Emporium. Bruno handed me a check for twenty-five dollars, patted me on the back, and said, "Son, you've just made a very good deal!"

Be Emotionally Fit

Always Assume You Won't Make the Sale

Protect yourself from feelings of disappointment by always assuming you *won't* make the sale. This crafty bit of self-hypnosis works to affect your entire presentation, assuring you won't make the sale no matter what.

Meanwhile, this simple strategy will prove to you just how smart you truly are: You knew you wouldn't make the sale — and you were right!

Know Why People Aren't Buying

Whether it's the economy, bad weather or "loser accounts," always have a *reason* why people aren't buying.

This way, when people ask how business is, you can tell them it's terrible — and tell them why.

Stated simply, your position is: "It's not my fault, it's outside my control." This will protect your ego through the worst of times.

In the best of times — when you're selling like mad — simply reverse your well-rehearsed rationale — from "It's not my fault" to "Because of *me*, business is booming!"

Then Again ...

"All complaints, save your breath. Nobody wants to hear it. Be optimistic."

— Jack Nicholson

Focus on Short-Term Frustrations

There are many stumbling blocks on the road to success. Rather than focusing on long-range goals — such as your sales progress over time — learn to dwell on minor set-backs and daily disappointments.

Better yet ...

Blame Everyone But *You* For Your Lack of Success

Recognize that every roadblock, every disappointment is the fault of someone else. You're not to blame. Nor are your lackluster efforts. So don't focus on you, focus on *others.*

In fact, spend enough time and energy blaming others for your lack of success and there's a better-than-even chance that the world — and everyone in it — will eventually *realign itself* to suit your needs, making it a world that finally revolves around *your* agenda.

All it takes is hanging in there 'til the world comes around.

Then Again ...

While this may sound incredible, many of us behave as if it were true. Because it's oh-so-convenient to blame someone else.

While speeding to get to the movies one night, I turned to my wife and asked why it is she's always running late.

"Well, if you took me out more often, I'd know how long it takes to get ready."

"So it's my fault?"

"Exactly."

Psych 'Em Out!

Maximize Your Importance

As a salesperson, it's essential to assume an attitude of absolute superiority, letting your customers know you're better than they are. (That's why you've chosen a field where you get to beg for a living.)

Boast to your customers about your wonderful family. Show off your clothes and expensive jewelry. Tell them you make tons of money. And let them know how lucky they are to be dealing with such a quality person as yourself.

Your hidden message?

Since I clearly possess superior knowledge and success, you would be well-advised to buy as you're told.

This behavior — guaranteed — will translate into major sales at premium prices.

Minimize Your Customer's Importance

Minimize your customers' importance by letting them know you're accustomed to dealing with *much larger* orders than theirs. Get them to see themselves as second class citizens — people who should feel grateful you've deigned to give them the time of day.

Train them with this lucky-you're-getting-any-service-at-all approach and you'll mitigate any problem that may arise from the sale. Grateful you're willing to deal with them at all, buyers will accept — even expect — deplorable service. Deliver sales or service even a half-notch above deplorable and you'll delight them every time.

Meanwhile, this lucky-you're-getting-any-service-at-all approach does wonders to spread good word of mouth, leaving them with that warm, incomparable feeling: *They knew what a small, insignificant fish I was and they still let me give them my money.*

Then Again ...

Nothing creates loyalty better than maximizing your customers' importance, because everyone *loves* to feel pampered and important.

While I was working at the advertising agency Young & Rubicam, a fledgling video production company courted our business. We gave them a try and they soon became a favorite supplier. What they delivered — beyond good work and competitive pricing — was such a level of fidelity and service that I was shocked to discover we were not their only client. That's how special they made us feel: As *if we were their only client.*

Same goes for David's, where I buy my clothes. The moment I walk in, it's: "Mr. Saltzman, thank you for coming in! How may I serve you today?" Immediately, David establishes a level of enthusiasm and service that becomes contagious: He's excited about selling clothes, and I get excited about *buying* those clothes.

Give Them Your Divided Attention

Giving a prospect your *undivided attention* sends the message: *I'm so desperate to get you to buy, I'm focusing all my attention on you.*

Better to give them your *divided* attention, letting them know: *This is a numbers game. If you don't buy, someone else will.*

In the retail world, this means bouncing from customer to customer, telling them: "I'll be right back—soon as I tend to this other customer."

Checking your watch is also good. This lets them know: *My time is valuable. I will not stand around forever waiting for you to make up your mind.*

Point to Your Record of Accomplishments

When they start to waiver, or doubt the value of your deal, let them know how successful you've been in the past. Tell them you've won "Salesman of the Year" the past three years in a row. Point to letters of thanks, plaques on the wall.

Finally, if all else fails …

Then Again …

Look to your record of accomplishment for *this particular sale*. If your customer waivers, ask yourself what else you can do to motivate him to buy; or ask him directly: "Is there something you're concerned about that we haven't discussed? What else do you need to know to make up your mind?"

Ask questions, keep probing, learn what it will take to make *this particular sale*.

Let Them Know They Can Never Return It

When your prospects try to give you the stall or just can't seem to make up their minds, caution them that once they stop waffling and decide to buy, there'll be no going back: "Once you buy this baby, it's yours for life. No refunds. No returns. No tears in your beer."

Then Again ...

Assuring your customers they can "always return it" greatly reduces the risk of purchase, turning many a Maybe into a Yes. Most people — even if they wind up hating what they bought — will never bother to make the return. Which means your 100% guarantee winds up costing you exactly zip.

Rite Aid, for example, started advertising that you can buy a lipstick there and, if you're not happy with it, return it for a full refund. How many people return used cosmetics? So few that Rite Aid keeps making the offer. Meanwhile, Rite Aid's money-back guarantee has boosted cosmetics sales by about 25%.

Likewise, at Blockbuster video stores, when you rent a Blockbuster Favorites Selection, "You'll love it. Guaranteed." If you don't, you're entitled to a free rental coupon, making your decision to "give it a try" that much easier. So more people rent more videos and Blockbuster builds customer loyalty for minimal investment.

Play
Unfair

Be Ignorant About Your Product

Being familiar with the product you're selling may be expected, but it's entirely unnecessary.

If they say: "What's the minimum purchase?"

You say: "I don't know."

If they say: "How does it come packed?"

You say: "I don't know."

Finally, if they say: "Can I return it?"

You say: "I don't know."

Being this ignorant will leave a lasting impression. They'll never forget the day you called and speak of you often to family and friends.

Then Again ...

The minimum standard for sales success is knowing about your product.

One day, I walked into a discount electronics store (part of a national chain) and told the salesman I was looking for a portable cassette recorder to tape my speeches. "Here they are," he said, pointing to three different models in the display case.

"What's the difference?"

"Price."

"That's it? Price? I can pay less or I can pay more?"

"Oh, no. The features are different."

"Such as?"

"I don't really know. You'd have to read the literature."

"You're not *familiar* with what you're selling?"

"It's impossible. We sell a lot of different products here."

"How about yourself? Do you sell a lot?"

"Not as much as the other guys."

"Ever wonder why?"

Leaving him to ponder that riddle, I went to another store where I found a salesman who knew his product.

When You Don't Know The Answer, Make Something Up

If you're ignorant of the truth, you can a) admit it, or b) be creative. Addressing the same scenario from the previous chapter, see how a little creativity can go a long way.

If they say: "What's the minimum purchase?"

You say: "As much as you'd like."

If they say: "How does it come packed?"

You say: "Whatever works best for you."

Finally, if they say: "Can I return it?"

You say: "Not only that, we'll pay freight both ways."

If you're prepared to help yourself — and you'd better be — you're prepared to say *anything* to make the sale. Meanwhile, being ignorant of the truth means you'll never be lying — just making things up that might even be true. Who's to say that car you're selling *won't* get a hundred miles to the gallon?

Certainly not you.

Be Belligerant

Let potential customers know how unhappy you are to serve them, making them feel lucky you let them in the door. Through your actions and attitude, let them know: *I despise you for being my customer and I can't wait until you're gone.*

Then Again ...

This actually works quite well in hair salons and upscale boutiques.

Reward Rudeness with More of the Same

Money talks and customers know it — causing a lot of them to be downright rude.

Say you're writing up an order and a woman edges in.

If she says: "I want my money back."

You say: "Can't you see I have another customer?'

If she says: "I said I want my money back."

You say: "In fact, it's a customer who's *giving* me money."

Finally, if she says: "I said I want my money back now!"

You say: "Listen, Lady. *I* have your money. If I were you, I'd be nice to me."

Then Again ...

Demanding customers can test you to your limit. Regardless of the provocation, refrain from lashing back. Take a deep breath, bite your tongue. Bite it off if you have to.

Break the Ice Without Stepping on Toes

When encountering a new customer on the floor, always begin with the words: "Can I help you?" This allows him to respond with a stress-free Yes or No.

Alternatively, opening with: *"How* can I help you?" may encourage your customer to tell you what he's looking for. But it can also cause needless discomfort: Forcing him to *explain* what he's looking for could cause *you* to admit you don't have it.

Better to stick with: *"Can* I help you?" If the answer's Yes, you're on your way; if it's a No, you've qualified him as a definite non-buyer and you're on your way to your next potential customer.

Then Again ...

For a slightly better question than "Can I help you?" how about *"How* can I help you?" That's not so easy to answer with a No.

Better yet, consider asking: "What brought you into the store today?"

"I'm trying to find a present for my wife."

"Smart man!"

Loosen 'Em Up

Now that you've broken the ice, loosen 'em up with a joke or two. And don't worry about being tasteless or inappropriate.

"I've got a good one," you might begin. "How many customers does it take to screw in a light bulb?"

"I don't know. How many?"

"Who cares? Long as I can screw 'em first!"

Give them plenty of time to finish laughing, then say: "Just kiddin' of course. How can I help you? I mean, 'What brought you into the store today and how come you're leaving already?' "

 Then Again ...

We've all had our ears bent by an amateur comic. (Some of us have even done the bending.) But when all you want is to make a simple purchase, bad jokes get can old very fast.

I went to a locksmith to get a new lock for my mailbox. I gave him a ten-dollar bill and he handed two dollars back, saying: "This is the difference. I call it the 'difference' because change can only come from within."

As a kid, my parents sent me to a dentist who thought he was a Borscht Belt comedian. "Just a little off around the ears?" he'd begin. "Or maybe a crewcut this time?" And those were just his "warm up" gags.

With Dr. Zipkin, drilling was the easy part; it was the jokes I couldn't take.

There's no excuse for holding an innocent party hostage to bad comedy. If you want to be a comedian, go find a night-club or channel your drive somewhere else. (Like writing this book, for example.)

Overpromise

The more you promise, the more they buy.

So what, if you can't honor the delivery date or stick to the price you agreed on? The only thing that matters is delivering their signature at the bottom of the order.

What happens later, when they discover you've fleeced them? That's *their* problem. Your problem was making the sale, a problem you successfully overcame.

What if they ask to return the goods or cancel the sale? Tell them you'll send them a "complete and total refund" — and that you want them to keep their purchase at no charge whatsoever.

That's losing money, you say?

No, that's overpromising.

Add On Like Crazy

Always sell your customers more than they need, adding on every needless gizmo, doo-dad and extra you can think of — like undercoating for a new computer. You make a bigger commission and they feel impressed with themselves for having spent lots of money.

Besides, the more they're sold, the more they're "sold" on you.

What if they don't need all the extras, you ask?

Why deprive them if they do? And why be frugal with someone else's money? Get them to spend as much as possible. Chances are they'll never realize you sold them too much. If they do, they'll remember you as someone who helped them buy more than they needed or could afford — which is what our great country is all about.

Then Again ...

Slam-dunk a customer by selling him things he doesn't need and you make a short term gain at the expense of future sales — not only from your dissatisfied customer, but from all those people he won't be referring to you.

What you want is Personal Trade, customers who will buy from no one but you.

"David's not in? I'll come back when he is."

Undersell

By underselling you keep the Total Amount Due to an absolute minimum, a sure-fire way to make most customers happy. And underselling is easily accomplished — either by selling them exactly what they came in for ("I need a new left shoe") or by failing to inform them of options and extras.

For the ambitious salesperson, underselling continues after the sale has been completed and the buyer is about to walk out the door. That's when you cement your relationship by informing him of all those options and extras you *could* have sold him.

Then Again …

Better to tell him about those options and extras *before* he's out the door.

I once left my car to be repaired at an electrical shop. When I came back to pick it up, the owner told me: "By the way, we also change oil."

"I need an oil change."

"Then come back again and we'll change it for you."

"But I left the car all day."

"And we fixed what you asked us to. No one asked us to change the oil!"

To avoid underselling, don't just sell them what they came in for; sell them what they *need*.

Oversell

Get your prospect so jazzed about a particular product that all he wants is *exactly* that.

Then — when you discover it's out of stock, discontinued or he just can't afford that particular model — he walks because you convinced him: "It's this or nothing. This is the one you want to buy!"

Don't sweat it, though. He'll be back soon enough — either when he does have the money or when you call him to say: "Hey, that discontinued item suddenly got undiscontinued!"

Shun Discount Coupons and Gift Certificates

When customers present a discount coupon or gift certificate, make them feel cheap. Let them know you work on commission and that the less they spend, the less you make.

First, act suspicious: "Gee, I'm not familiar with this kind of gift certificate."

Next, try to humiliate them: "You must be a cheapskate."

Finally, make it more of a hassle than it's worth: "Sorry, I'll have to show this to the manager. He'll be back in a couple of weeks. Why don't you come back then and be sure to bring two forms of picture ID, at least one of which features a flattering picture."

Meanwhile, your store's Gift Certificate remains exactly as intended: a simple piece of paper for which someone paid ten, twenty, maybe fifty dollars and — if you're lucky and persistent — will never be redeemed.

Be Blasé

When a customer thanks you for being helpful, shrug: "No problem."

Letting him know he was a problem-free customer is your way of saying: "Don't worry about me; I'm just doing my job."

Remember, if your customer says: "This is great, just what I was looking for. I can't believe you have exactly what I need. And the price is unbelievable! Thank you. Thank you so much!"

You shrug and reply: "No problem."

Leave your customer with this no-skin-off-my-nose sentiment and he'll surely return to buy more goods and enjoy more good feelings.

 ## Then Again ...

When a seller says "no problem," I internally go ballistic. *I don't care if it was a problem, I'm giving you business here. I'm putting food on your table!*

What I want to hear is someone who's grateful for my business. Your telling me it's been "no problem" for you is not what I call inducement to return.

I once went to buy a bulletin board for my son so we could hang up his art work. I told the salesman how excited my son would be, and we wound up talking about kids and their artwork. I thanked him, he thanked me, and I left that store feeling great.

Not every sale has to include a down-home chat or a sit by the fire. But a few friendly words, even a "Thanks for the business," goes a long way.

Keep Prospecting

Take Established Customers For Granted

The longer your business relationship, the more relaxed — and lax — you can afford to become. Not only will you not have to work so hard at making them happy, but pretty soon you won't have to call on them at all.

That's why we say ...

Make New Sales, Not Resales

It's easier to find a new client than ask an old one to buy again —
especially once the relationship has soured. Better to keep find-
ing new prospects, people who will be unable to say: "I've done
business with you and it is not an experience I'd care to repeat."

Fortunately, the world's population continues on the upswing,
delivering new prospects every day — people who have yet to
hear from you and won't turn away the moment they do.

After all, why go back to the well when it's already poisoned?

Remember: Do not follow the

Start at the Bottom

Don't risk annoying people by going over their heads. When selling to a new account, always start your efforts with the lowest person on the ladder, then crawl your way up. Safer to "start low and stay low" than make a fast sale by going straight to the top.

advice in this book! (Unless

Fail to Qualify

By *not* qualifying, you allow yourself to pitch to anyone who's willing to listen — including people with zero money, little sense, and no authority to make a buying decision. This results in a major upside: By actively *not* qualifying, you'll wind up doing full scale pitches to a lot more people. And all that extra pitching is sure to result in improving your game.

inside a "Then Again" box.)

Let One Call Say It All

However you make your sales pitch — by letter, phone, fax or in-person — let *one sales call* represent the sum total of your sales efforts.

You may have heard a lot about the "call-write-call" or "write-call-write" approach. Sadly, both these approaches mean *three* sales calls when you should only be making one.

Persistence is the key to success? Persistence is your way of saying: "I need your business so much, I'm willing to keep knocking at your door 'til you let me in."

Better to let *one call* say it all. If they fail to immediately appreciate the value of your deal, it's their loss not yours.

Buyer beware: "Turn away from my deal today and I won't be back to beg again."

That's telling them.

Bombard Them

If you lack the nerve to "Let One Call Say It All," learn to bombard them.

Whether you're sending faxes with so-called "Important Updates" or leaving phone messages marked "Urgent," bombard your prospects with endless communications. Soon, they'll realize that every fax with your name on top is a fax to be ignored, and every "While You Were Out" pad bearing your name means one more call they needn't return. Even those mailings of yours can now be recognized for precisely what they are — petty annoyances to be tossed unopened.

Constant bombarding sends the message: *I'm in your face and I'm not going away.* Eventually, all your prospect can do is throw up his hands and admit defeat. *Enough already, I'll place an order. Anything to get rid of you!*

Then Again ...

Repeated impressions make lasting impressions, keeping you and your company highly visible.

Consider, however, a judicious approach. Contact a prospect only when there's something important to be conveyed. This sends the message: *"I care about your time and don't want to waste it."*

Nearly every week I get a "great new offer" faxed to me by the Acme Co. And most of those offers turn out to be pretty much the same old offer they pitched me the week before. Now, soon as I see the Acme Co. logo on top of a fax, I toss it unread.

Got a brand-new fax or e-mail broadcaster? Use it with discretion or lose credibility.

In contrast, consider the salesperson who contacts you *judiciously.* "Oh, this must be something I should take a look at. Otherwise, Eddy never would have sent it."

Be Impatient

Someone once said that impatience is anger at things not going your way. *And damn right he was!*

Keep hounding your prospects by repeatedly asking: "When are you going to decide in my favor?" And let them know of your righteous impatience. "If you were smart enough to know what was best for you — and apparently you're not — you'd be returning this call right now to place the biggest order this office has ever received!"

Better to place that order, they'll soon figure out, than needlessly fuel your righteous indignation.

Then Again ...

We've all felt like shouting: "Don't these people realize how desperate I am to make this sale!"

No, they don't. And if you keep your mouth shut, they'll never find out.

Take It Personally

When a prospect fails to return one or more of your calls, it's tempting to take it personally — and appropriate.

A prospect who doesn't call you back is saying: "I can't be bothered by YOU. I have time and interest for other people, but not for YOU."

Taking things personally, you can now proceed with your eyes open wide. And if you do get him on the phone, don't hide your feelings. Be open. Share. Tell him: "You were mean and uncaring to me, placing *your* needs above mine."

So what if you risk alienating a prospect or lose him altogether? Better to square things now than harbor ill will that could negatively affect your future dealings.

Then Again ...

Consider this bit of advice from a well known Hollywood agent. "If I need to speak to someone, I place as many calls as I have to. I don't care if takes me twenty tries to get through. Eventually, I get that person on the phone and I always begin with the exact same words: 'So, how was your golf game last week?'"

"I eat shit for a living," he confides. "And it pays very well."

Put Your Anger In Writing

When frustration gets the better of you, put it in writing. Say you're a sales rep who's been calling on an account for a number of months and they've yet to place an order. Write them a brief, professionally worded note:

"I am writing to inform you that from this time forth I will never call on your business again."

This puts your cards squarely on the table, encouraging your non-account to swiftly write back:

"Please, oh please. Won't you please reconsider?"

Then Again ...

Don't call, write, e-mail or fax anyone *anything* until you're 100% dead-bang certain: *This is exactly what I want to say and I am willing to have those words tattooed on my forehead.*

By the way: That story about the sales rep (above) is true. Not only did he burn a bridge with his non-account, the person he wrote that letter to sent a copy to his boss. In fact, the only reason he wasn't fired was because his boss was his dad, though he did get threatened with a spanking if it ever happened again.

Use a Spell Checker to Catch Your Written Errors

Before you send out even the briefest of letters, be sure to run it through your computer's spell checker. You'll save yourself needless embarrassment and present yourself as an accomplished wordsmith.

Then Again ...

One think you will fund is that a lot of words — even if you spill them wrong — will smell other warts and Spell Chick won't knew one from the otter.

Knock the Competition

Let your customers know they'll be making the "biggest mistake" of their lives if they buy the other brand. Tell them: "Think of me as your guardian angel. I'm here to protect you."

Once your customers discover you're not just a salesman but an angel, they'll readily take you at your self-serving word.

What if you wind up switching jobs one day and working for the competition you used to brutally knock? Just call up your old accounts and say: "C'mon, didn't you know I was kidding?"

Call to Complain

When a prospect goes with your competitor, call to warn them: *You've just made the biggest mistake of your life. How could you do this to me?*

Meanwhile, avoid asking why they went with someone else, or what you could do to win their business today or in the future. This shows you're admitting defeat and implies they've made an informed buying decision.

Tell Them You'd Like to Be Considered in the Future

When courting a prospect that already deals with your competitor, learn to practise the softest approach possible. Rather than boldly making a proposal or demonstrating your wares, place responsibility on the shoulders of the *buyer*. Let him know: *If you ever think about giving your business to someone else, give us a call.*

This is akin to the well-practiced, though seldom-rewarded, marketing strategy: *If the phone rings, I answer it.*

Then Again ...

It pays to be aggressive. And persistent.

In 1981, when the advertising agency DDB Needham lost the McDonald's account to competitor Leo Burnett, Chairman and CEO Keith Reinhard refused to admit defeat. For fifteen years he kept sending McDonald's new campaigns his agency had created for the fast-food leader. Finally, in 1997 McDonald's decided it was time to split from Leo Burnett and wound up going — big surprise — back to Needham. The value of the account? $385 million a year.

True Story

Thinking about selling our house, my wife and I went to two open houses in the neighborhood, to see what the competition was like.

At the first house, after pretending to be buyers, we admitted to the broker why we were really there. "Oh," she said, "are you working with a broker?"

"Yes, we are."

We weren't, but it seemed like the easiest thing to say.

"Well," she said, handing me her card. "I'd still like a chance to compete for your business."

At the next open house, after pretending to be buyers, we again told the broker why we were really there. "Great," she said. "Tell me about your house."

So we did.

"Well, you know something?" she said, "I met a couple of people today who are looking for a house like that. I'd like to send them to *your* house."

Three months later, that second broker sold our house.

Meanwhile, every two weeks or so that first broker would leave the same, sorrowful message on our voice mail: "I'd still like a chance to compete for your business."

Know How to Use the Telephone

Soon as the Phone Rings, Put Them On Hold

Learn to pick up the phone and immediately ask: "Can I put you on hold?" Then, before they have a chance to respond, switch to another line, even if there's no one else on the phone. This will impress your callers by letting them know you're a busy professional, not someone who's sitting around waiting for the phone to ring. Even if you are.

As you practice this technique, try to keep each caller on hold for as long as possible, gradually increasing the amount of time. Soon, you'll be putting them on hold for three, five, even ten business days.

Then Again ...

When you automatically put a caller on hold, it sends the message: *Whatever I'm doing is more important than you.*

When you find out who it is and *then* put them on hold, it sends the message: *And now, I'm sure of it.*

Imagine. Some people still pick up their phone and cheerfully ask, "How can I help you?" — words that make just about anyone melt.

Tell Them You're Too Busy to Talk

When you do return to pick up their line, tell them: "I'd love to speak with you, but it's not a good time."

To further impress them, ask: "Could I call you back tomorrow?"

To *really* impress them, ask: "Could you call *me* back tomorrow?" This response will set you apart from the everyday sales crowd.

True Story

A restaurant owner calls a printer to discuss some menus he needs. "I'm kind of busy right now," says the printer. "Could you call me back tomorrow?"

"Tell you what," says the caller, "why don't you refer me to another printer and I won't have to bother you again."

Fail to Extend Yourself

When what your caller needs isn't *precisely* the product or service you provide, be sure to tell him: "We can't help you and we don't know who can." If you're feeling particularly generous, you might suggest he look in the Yellow Pages.

Let's say you sell and service spas. A customer calls and says: "You had a spa cover custom made for us and we need to have it repaired." You say: "Call someone who does upholstery. That's what we tell everyone who has a problem with their covers. Oh, and if you ever need a new spa, give us a call."

Your customers will appreciate your helpful advice and be sure to call *you* the next time they need help.

Never Return a Call
The Same Day It Comes In

To return a call promptly says you're hungry for business. As a rule, wait at least a week before you call them back. Two's even better.

When you do return their call, open with the words: "Sorry I took so long. What can I do for you?" This tells them you know you've done wrong, but now — at a time that's convenient for you — you're ready for business.

Wow, thinks the buyer, *this guy doesn't need me from a hole in the head and he actually called me back! I can't wait to give him my business.*

True Story

A screenwriter is offered an assignment from a major producer. So he calls an agent he knows to negotiate the deal. He calls him again. Two weeks later, his call is finally returned.

"Frankly," says the writer, "I took your not getting back to me as an indication of your lack of interest in this deal."

"Not at all," says the agent. "What can I do for you?"

"Nothing," says the writer. "I found someone else."

Wait. It gets better ...

The screenwriter winds up winning an Academy Award for his script and, during his acceptance speech, he makes a point of thanking his "non-agent," Barry Big.

Next day, Barry gets a flurry of calls. And they all want to know: "What did he mean you're his 'non-agent?'"

Okay, the acceptance speech part didn't really happen. But it should have.

When Leaving a Message, Say Whatever Comes to Mind

Leaving a voice mail message is your opportunity to shine — to prove to your prospect just how clever you are.

Think of voice mail as your personal microphone, like Open Mike Night at your local comedy club. Be spontaneous and wow 'em with pizzaz, leaving a witty-as-heck message they'll be sure to savor and play again and again for the amusement of others.

Then Again ...

Being spontaneous can backfire big. Not only that, they've got it on tape.

Before you leave a voice mail message, know exactly what you want to say. If necessary, hang up and mentally prepare your message. Write it out if you have to. But don't call back until you're prepared to leave a message that may outlast you.

Same goes for shooting out an e-mail. Before you risk shooting yourself in the foot, print out a copy and thoroughly review it.

Let the Buyer Beware

State Their Risk Up Front

We live in a quickly changing world. What's offered as today's solution may soon spell disaster.

To avoid placing yourself at risk, do not attempt to offer solutions; offer *options* and let the buyer beware: *This is your choice, your decision. Any effect this product or service may have on you, your business or your heirs is* your *responsibility.*

Avoid Discussions of Their Bottom Line

The moment you suggest how a proposed purchase will affect their bottom line, you've set yourself up for personal failure: If you succeed, they'll reap the profits; if you fail, they'll turn around and blame *you* for their woes.

Better to remain a dispassionate third party, someone who says: "I'll sell this to you, but the risk is yours."

Make No Guarantees

Making any form of guarantee is guaranteed to cause you problems. And making a *written* guarantee is the biggest mistake you can possibly make, especially when selling inferior goods. Instead, tell your customer: "If a problem develops, I'll do my best to fix it."

Should a problem arise, they'll soon discover your "best" is far from adequate — which is their problem, not yours.

Did they stop to ask: "Just how good *is* your 'best'?" No, they did not.

And think how good you'll feel about yourself, knowing you've provided your customers with a learning experience they'll not soon forget.

Avoid Extended Warranties

Extended warranties can be *huge* profit centers — especially if you go out of business and they're left holding a worthless piece of paper.

But there's a downside as well: When you sell an extended warranty, you risk extending the life of your product, thereby extending the sales-cycle.

Forgo the extended warranty and it's short-term gain. Better to let them buy *without buying the warranty* and have them return to buy a new one soon as the old one breaks.

Always Deliver Less Than You Promise

Whether it's the twelfth egg or the floor mats you promised, always be sure to hold something back. By delivering less than you said you would, you force the buyer into calling you up or returning for satisfaction. This gives you the opportunity to "save the day" by making good on your word.

Think of it: What would normally have gone unnoticed — just "part of the deal" — is now emblazoned in the buyer's mind. "He said he'd give me twelve eggs, and by golly he did!"

Be a Whiz at Sales Presentations

Wing It

Make each sales presentation spontaneous and exciting by "winging it" — making it up as you go along. Flying by the seat of your pants, you'll soon discover just how exciting sales can be. You'll present a spontaneous, off-the-cuff image. And your courage and daring will be sure to impress.

Don't sweat the details and don't sweat the prep. Say whatever comes to mind and hope it's something good.

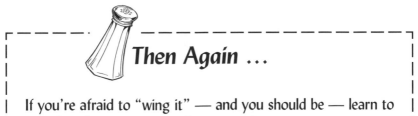

Then Again ...

If you're afraid to "wing it" — and you should be — learn to be a Boy Scout presenter: *Be prepared.*

Fail to Appreciate in Advance Problems with Your Product or Service

Once again, learn to "wing it," responding to objections with spontaneous quips like: "Gee, you're right."

 Then Again ...

Be Prepared
Anticipate objections and create well-rehearsed responses designed to stop them in their tracks.

Can It

If you're afraid to "wing it," fully prepare with a canned presentation. Write out a script and memorize it word for word. And be sure to rehearse every gesture and pause.

Think of yourself as a flight attendant giving pre-flight instructions: Know when and how you will move your hands, head and eyes, and never stop to entertain questions. You'll deliver a polished, poised, professional performance, causing many in your audience to actually wonder: *Is this person live or is he on tape?*

Demonstrate Poorly

The best way to show your product is superior is to *demonstrate*, giving them "proof" that what you say is true.

Suppose you want to prove how the flashlight you're selling is indestructible. Simply take your flashlight and throw it to the floor. When it shatters into a million pieces, you'll get a good laugh. Then say: "Well it's not *really* indestructible. What is these days?"

Next, take your competitor's product and do the same thing. When it *doesn't* explode, tell them: "See how honest I am? I've just shown you the absolute truth!"

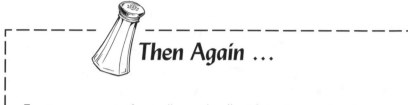

Then Again ...

Eager as you may be to "wow 'em" with an impressive demonstration, to avoid embarrassment (like having to apologize for an exploding flashlight) do what the pros do: *Practice at home.*

This bit of advice comes from a croupier in Las Vegas. After a college age player at the craps table accidentally threw the dice *off the table* twice in a row the croupier whispered in his ear: "Why don't you practice in your bathtub at home?"

I took his advice to heart and have never been sent to my bathroom again.

True Story

We've all seen the huckster who demonstrates how the Cut-O-Matic slices, dices, peels and pits, *saving you from hours of tedious kitchen drudgery* (a real product benefit). But what if your product doesn't "demo" with panache? You might just have to add some of your own.

In 1991, a Canadian inventor named Gallant met in New York with the game and puzzle buyer for F.A.O. Schwarz. Without saying a word, he took a replica of a well-known Canadian building and tossed it in the air. It fell to the floor, but remained in one piece. Then he picked it up and started taking the interlocking pieces apart, demonstrating that it was really a puzzle. To which the buyer said, "Wow, where did you get that?" (No sweeter words were ever heard!) Immediately, the buyer placed an order for 72 puzzles and they have been stocked by most of the company's stores ever since.

Six years later, Gallant's company, along with Hasbro, turned out more than 10 million three-dimensional puzzles. And it all started with Gallant's ability to demonstrate with panache.

Hand Out Your Literature
During Your Pitch

Timing is key: Hand out lots of literature *during* your pitch. This should keep their eyes on your handouts and away from you. The buyers' attention now divided, if you do slip up or say the wrong thing, chances are they won't even notice.

Take More Time Than They Give You

By keeping your pitch within the allotted time, you convey the message: *I'm someone who follows the rules.* Instead, go over time — way over time — demonstrating just how much this sale means to you. Your prospect will appreciate your dedication and reward you in kind.

Keep Lowering Your Price

Remember: Should people challenge your price, simply ask them: "How much cheaper would I have to make this for you to say Yes?" The lower you go — and the faster you get there — the faster the sale.

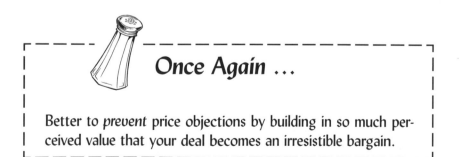

Once Again ...

Better to *prevent* price objections by building in so much perceived value that your deal becomes an irresistible bargain.

Let Your Literature Do the Talking

Always Offer to Send a Brochure

Offering to send out literature about your product is a sure-fire way to advance your cause.

If you say: "Can I send you some product literature?"

They say: "Sure."

This scenario will play out nearly 100% of the time — even when they're 100% convinced they have no intention of buying your goods. By creating the appearance they *might* be interested, it conveniently lets you both off the hook.

They don't have to say: "Thanks, but no thanks."

And you don't have to say: "Thanks to you, my family's going to starve."

Make Sure Your Materials Need to Be Updated

When sending out product literature, be sure it's out of date. Explain to customers: "These aren't our latest models, and prices have gone up a bit, but it should give you some idea of what we have — or had — to offer."

Keeping your product literature out of date sends the message: *We're so busy making money that we just don't have the time to do things right.*

Then sit back and watch what happens: Potential customers — impressed by how busy and successful you must be — will break down your doors to send you more business.

Mark Every Envelope "Urgent!"

So what if you're lying? This is your way of saying: *If you knew what this was, you'd consider it urgent and open it immediately.*

What happens when they look inside and realize you've duped them? They'll appreciate your ingenuity and want to reward you by sending you business.

Make Handwritten Changes on Your Business Card

Like product literature, your business card is a statement of who you are. A handwritten change — like a new telephone number or a different address — makes the statement: *I'm so darn busy, this is the best I can do.*

With luck, that same implicit message will serve as the foundation of your sales pitch, conveying to prospects: *I'm way too busy to sweat the details but if you buy what I'm selling I'll do the best that I can, time permitting.*

Know
What to Do
After
They Buy

Avoid Buyer's Remorse by Avoiding the Buyer

Once you've converted a prospect to a buyer, do your best to keep out of sight.

Others may recommend sending a letter ("Congratulations, you've just made a very smart purchase!") designed to make the sale stick. But what if your buyer doesn't share your excitement? Better to "duck and cover," remaining out of sight until his disappointment blows over.

Sending a "stick" letter — especially one that includes your phone number or business card — is like painting a target on your back, one that says: "In the event you change your mind, here's how to contact me to cancel the sale." Why not go one step further? Why not rip up their check and pop it in the mail *before* they complain?

Want a secure, happy customer? That's up to you. First work on creating a secure, happy *seller*. The moment you have their check in hand, vanish with the wind.

Alternatively …

Place an Automated "Check Up" Call

After the product or service is delivered, follow-up with an automated "check up" call to monitor customer satisfaction. Imagine how impressed your customers will be when they listen to a computer chip that asks: "Are you happy with our product? Press 1 for Yes and 2 for No." Meanwhile, your "high-tech" presentation let's them know you're state-of-the-art and have zero interest in forging a relationship.

 Then Again ...

Absurd, you say? Who'd use a *computer chip* to ask customers if they were happy? That's what I said when my local phone company polled me after I signed up for voice mail.

How's this for advice? If you want to check on customer satisfaction, do it in a way that won't annoy your customers!

Turn a Deaf Ear to Customer Complaints

Customers who complain are people who want something other than what you're providing, which, if you try to convert them into "satisfied" customers, can only result in extra work. In fact, *five percent* of complaining customers will never give you another order — even if you resolve their problem on the spot.

Better to turn a deaf ear to customer complaints, letting them know you have no intention of trying to make them happy. Instead, focus your energies on brand new prospects — situations where 100 percent of the time you still have a shot at making the sale.

Then Again ...

If you can resolve their problems, most people will remain your customer. They may even become *loyal* customers, knowing you worked to make things right.

Be aware, however, that hell hath no fury like a customer scorned. Turn a deaf ear, or fail to make things right, and they'll make it a point of spreading the news with a vengeance.

I once belonged to a health club that began to lose points on my Customer Satisfaction Index. My biggest complaint was the declining level of hygiene in the Men's Room. (My bathroom in college looked better.)

How did the manager react when I complained? He said: "Do you know how hard it is to find good help these days?"

He also told me how "lucky" I was because, according to him, other health clubs did not permit their members to work out in sleeveless shirts.

"Tell you what," I said. "You keep the bathroom clean, I'll work out in a tie and jacket!"

Ten years later, whenever someone mentions they're thinking about joining that health club, I make sure to tell them the whole crazy story.

Blame Someone Else at Your Company

Unless you're the president of the company, there are always people above you. Blame it on them. Tell your customer: "If it were up to me, you would have received the proper goods at the promised price, delivered on time. But the people I work with are not the best. I apologize for their behavior and assure you that the shabby treatment you received will not be experienced by another customer."

Blame Someone Else's Company

Even better, blame the problem on another vendor. A dry cleaner, for example, when faced with a customer whose suit he ruined, might respond: "The problem is you bought a cheap suit."

While a customer who's been wronged can turn out to be your company's greatest supporter — assuming you manage to make him happy — why take the risk? Better to "pass the buck" to someone else.

For example, you might …

Blame The Customer

Explain how he misunderstood some part of your agreement.

Let's say he complains that your final bill is double your estimate. Tell him: "It was an estimate, not a contract." Once he understands he didn't understand, he'll promptly apologize and let the matter drop. Courteous customers may even offer a *written* apology.

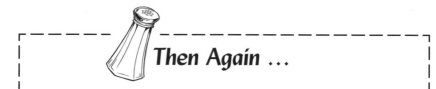

Then Again ...

Assume responsibility. If you're wrong, admit it. Then do your best to make things right.

Recently, my wife had her car repaired by the dealer. Dropping her off to pick it up early the next morning, I pulled into the service area, packed with cars waiting for service. In fact, it was such a tight fit that I later asked an employee to direct me out. Which he did — until the side of my car scraped against a concrete planter, causing a fair amount of damage.

I parked, found the Service Manager, and told him my story. He went out to the car, took one look and said to me, "We'll take of it."

And he did.

Explain Why Things Went Wrong

When something goes wrong — whether the goods don't get there on time, or the wrong goods arrive — customers don't want things corrected, they want things *explained*. Tell them: "Let me explain what went wrong." This sends the message: *We're up to speed. We know precisely how and why we screwed up.*

The alternative — correcting their problem — may leave some customers thinking: *If they're so eager to please, they must be desperate for business.*

Say You're Sorry

Whatever the slight, omission or mistake, just say you're sorry. You won't do anything to *fix* things, but you are willing to apologize. This costs you neither money nor work and shows your customer you truly care. For example:

A customer tells the waiter: "This soup is so hot I burned myself."

"I'm sorry," says the waiter. "Why don't you wait for it to cool down?"

Question: When it's time to write up the bill, should the waiter take the soup off?

Answer: Absolutely not. That would involve trying make things better. Better to say "I'm sorry" and leave it at that.

Be Slow to Make Good

When offering to fix things like a bad haircut or a missed delivery date, let customers know you'll be glad to help them — at *your* convenience.

Say your customer calls complaining: "It's a terrible haircut. I can't leave the house without a hat on." Tell them: "I understand how you feel. How would a week from next Wednesday be?" Let them know you care about making them happy — but you have your non-complaining customers to take care of first. "Besides," you might add, "I already have *your* money."

Never Let Them Return The Goods

If a customer is unhappy with his purchase, explain that his expectations were unrealistic.

If your product failed to perform as promised, tell him his memory is at fault. "I never said it would do that. I would *never* say that. I don't even remember selling this to you."

Finally, if he still wants to cancel the sale, tell him: "Sorry, all sales are final — unless you're willing to pay the 100% restocking charge."

Tell Them It's Policy

To gain a quick advantage with customers, patiently explain that any slightly-out-of-the-norm request is totally-out-of-the-question because: "It's against our policy." This lets them know there are strict procedures to be enforced and you're not about to break the rules.

If your customer says: "It's three minutes past five. I don't care if you are closed. I've got dry-cleaning to pick up. Now let me in!"

You say: "It's against our policy."

If you feel that's too harsh, soften the blow by saying you're sorry, as in: "I'm sorry, it's against our policy."

Then Again ...

To build lasting relationships with customers, practice customer-minded thinking and behavior — and avoid rigid policies.

When Steve Bosley took over the Bank of Boulder in 1974, he posted signs declaring a radical change: "Our only policy is no policies."

Employees were urged to "practice nonrigid thinking" and get "in sync with people's needs." Bosses were instructed to hire well, train thoroughly and "get out of the way."

By 1996, Bank of Boulder reached $122 million in assets — up from $1.5 million before Bosley arrived.

Post Tiny Signs You Can Refer to Later

Whether it's "Alterations Extra" or "All Sales Final," make sure you post tiny signs in inconspicious locations. Later, you can point to them and say: "See, it says so right there." Think of these signs as "fine print wallpaper," public postings that can't be denied — even if they were designed to go unnoticed. Which they were.

Don't Ask

If they do succeed in returning the goods or canceling your service, *never* ask why. This protects both of you from a potentially embarrassing situation. Besides, if you discovered what the problem was, you might have to do something about it, either to save the sale or protect the next one.

Don't ask, hope they won't tell, and avoid the problem of creating extra work.

Then Again ...

Ask your customer *why* he wants to returns the goods and you might win a second chance.

A few years ago, I called our local paper to cancel my subscription. "May I ask why?" asked the operator.

"Because we already get *The New York Times* and *The Wall Street Journal* and we just don't have the time."

"How about Sunday service only for half the price you'd pay at the newsstand?"

I didn't want the paper, not even on Sunday. But it was such a great deal, I just had to say Yes.

Meanwhile, that Sunday-only service eventually got us back to daily delivery.

On the other hand ...

When I phoned my cable company and told the operator I wanted to cancel their service, she said: "Okay."

Not such a good ending, is it?

True Story

A man visits clothier Malcom Levene and buys a four-thousand-dollar overcoat. Next day, his wife sends him back to return it. Not only does Levene persuade the man to keep the coat, he takes the opportunity to sell him two suits — for an additional sale of two thousand dollars.

Levene's philosophy?

"A return is not a return — it's an opportunity."

Give Them an 800 Number to Call

If complaining customers insist on being a nuisance, give them an 800 Customer Service Number to call.

One: This gets them out of your hair.

Two: Everyone loves a toll free number.

If you don't have an 800 number, make one up. They won't find out until you're well out of sight.

Hound Established Customers For Unpaid Bills

The longer they remain your customers, the more likely they are to treat your invoice as a "payment suggestion." When this results in a Balance Due, be sure to act swiftly and severely.

Regardless of the amount of money involved, hound delinquent accounts like the deadbeats they are. Call. Write. Call them again. Tell them: "While I appreciate your sending me business every month for the past twelve years, you still owe me nine dollars."

"Boy, business must be bad if you're hounding me for nine dollars."

"Business is fine. Nine dollars is nine dollars."

Meanwhile, don't allow customers to sidetrack you with discussions of friendship, your long term relationship or "problems with accounting." Stay centered and focused and get what you deserve.

What if you get the nine dollars but lose the account?

You'll be nine dollars richer — money which can now be used towards advertising and promotion to win a better class of client.

Then Again ...

Before you call, think things through.

Remember David's, the place I go to buy my clothes? He called me one day to tell me: "I forgot to add in the socks. You owe me nine dollars."

That one phone call nearly ended our relationship. After spending thousands of dollars over a ten year period and sending him a fair amount of business, he picked up the phone — without stopping to think — and asked me to send him a check for nine dollars. (I still shop at David's, but I might just pay a visit to Malcom.)

Regardless of the sum involved, *think things through* before you pick up the phone. Don't be like that partner at a small law firm who called a delinquent account and started yelling: "Because of you I can't pay my mortgage!"

"Things that bad?"

"Yes, they are."

"Okay, let's negotiate!"

Introduction

Now that you've been exposed to some of the worst beliefs and techniques in the world of sales, it's time to introduce the real work ahead:

Avoid the advice in this book 100%
unless it's contained in a "Then Again" box.

If you find yourself tempted to embrace even a single technique or point of view presented outside those boxes, promptly point yourself in the *opposite* direction.

Meanwhile, keep this book as a carry around, a constant reminder of how to become "The Worst Salesman in the World" — and how to avoid it.

About The Author

Joel Saltzman is a high-octane, high-content speaker who teaches people in business to *Shake That Brain!SM* and discover solutions for maximum profit. A former comedian, he's known for delivering both substance *and* entertainment.

Previously with the advertising agency Young & Rubicam, he's a co-author of *Selling With Honor* (1997) and author of *The Worst Salesman in the World* (1999). He's created sales and training materials for AT&T, Johnson & Johnson, Minolta, and the USA Network — and pure entertainment for television sitcoms.

A former speechwriter for Fortune 500 executives, Saltzman also coaches business people to write and deliver their best presentations ever with his "speak easy" approach to powerful presentations.

He's been a guest on CNN, NPR and NBC's "Leeza Show."

As **J.S. Salt**, he's the creator of *Always Kiss Me Good Night: Instructions on Raising the Perfect Parent by 147 Kids Who Know* (Random House, 1997), a book that became the #1 Best Selling parenting book in America.

*Shake That Brain!*SM
Toll Free: (877) *Shake It*

Visit the *Shake That Brain!* Web page at:
www.**shake**that**brain**.com